All work in

Marker & Ink

Bullet

So this is the bullet for the job.

House

I love me some modern house.

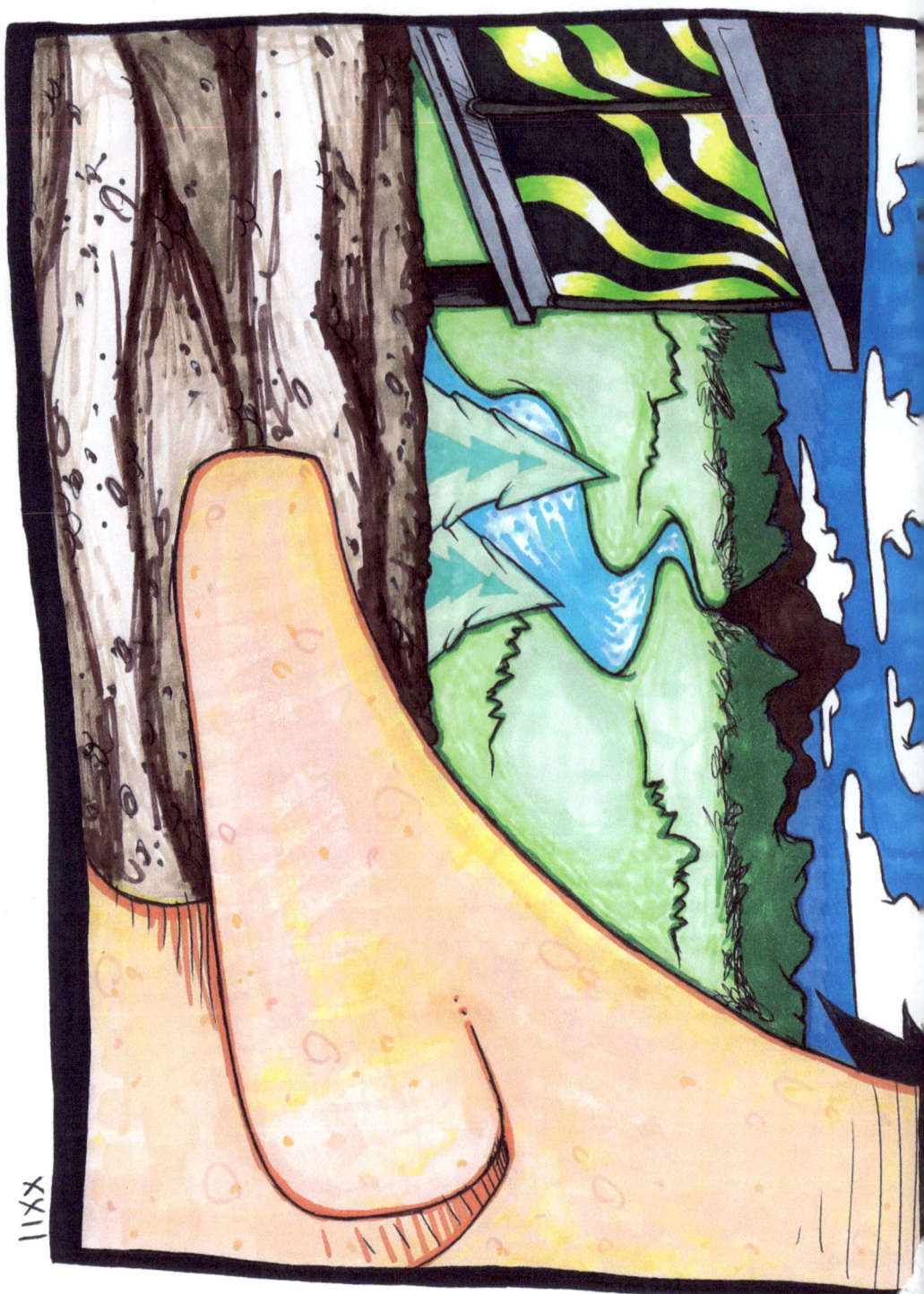

Nose

Modern house on the left, nose on the right, nuff said.

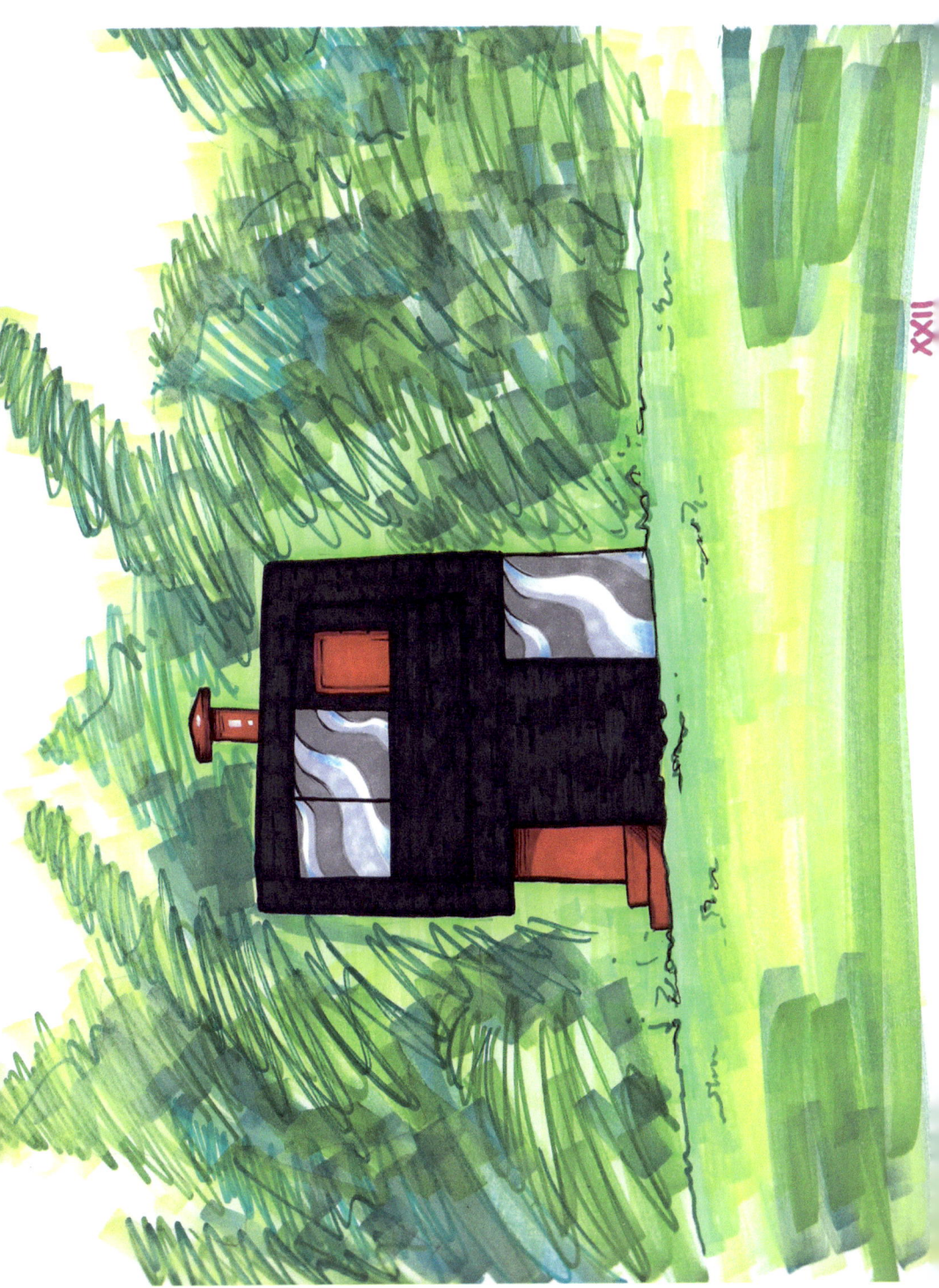

Livingroom

I couldn't think of anything to draw, so I drew the livingroom.

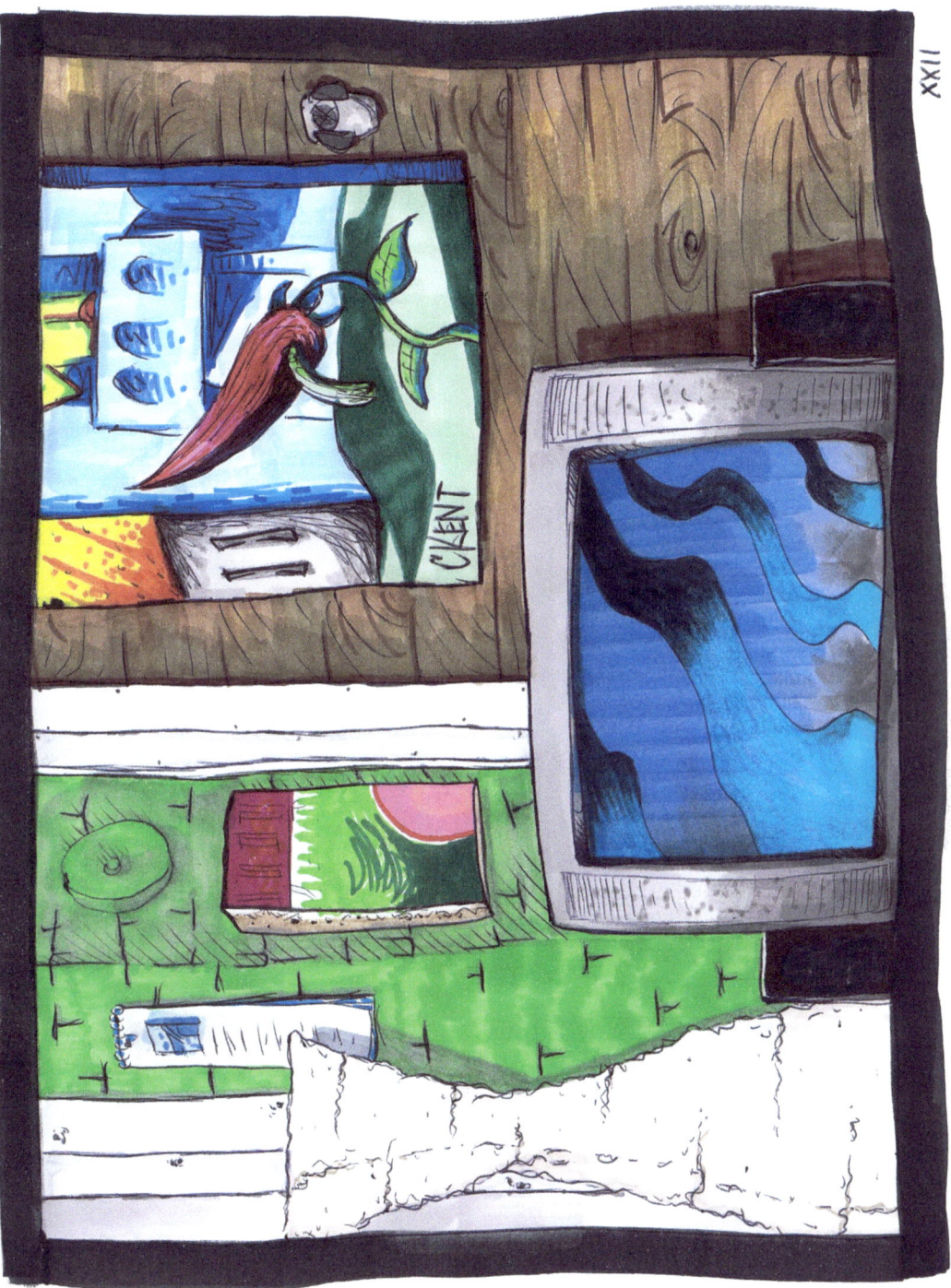

Kundig

Love Tom Kundig Architecture.
a little nod

Do-Ho Suh

His incredible silk work, had to show some love.

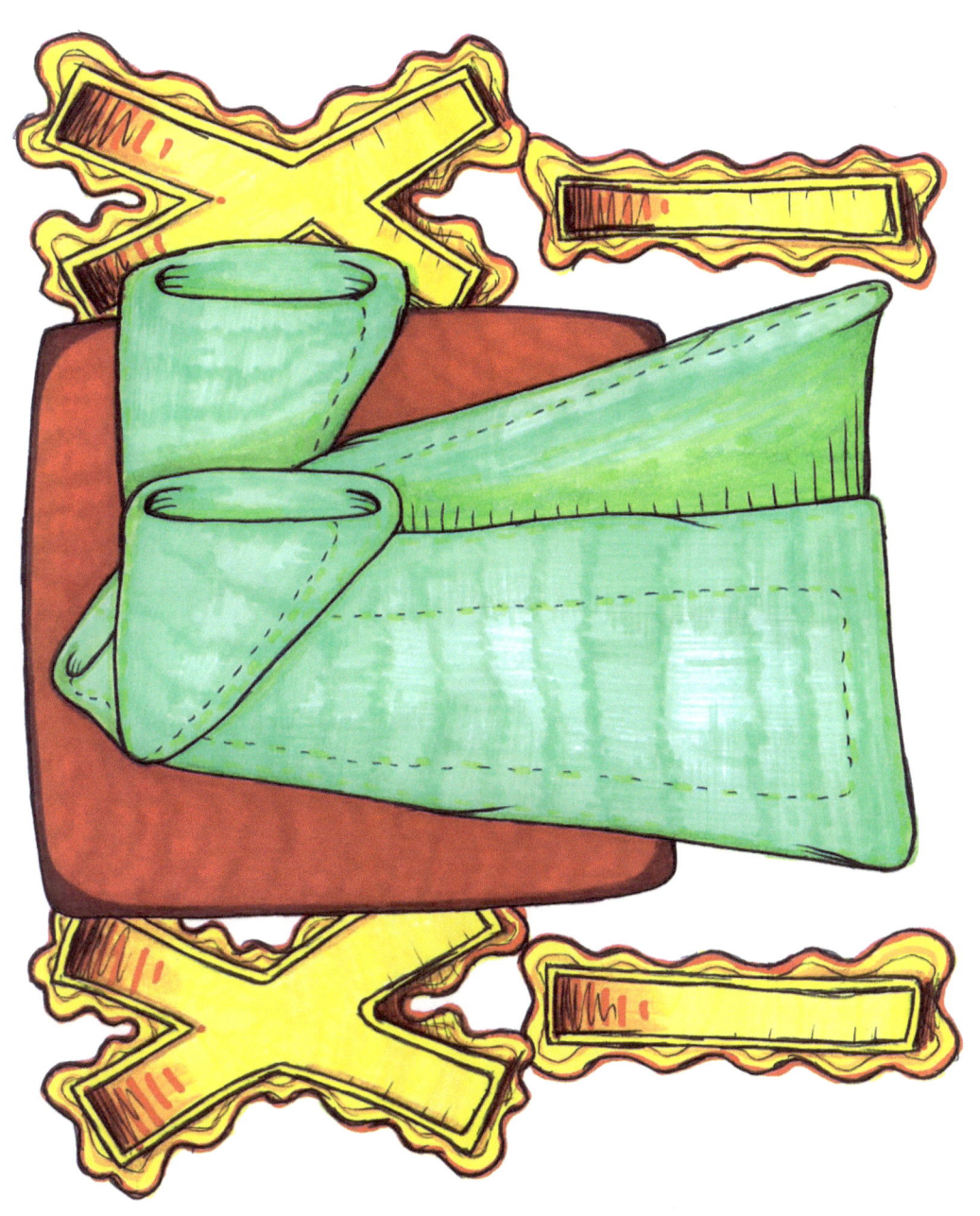

Lilly-Skull

Skulls and flowers always work right?

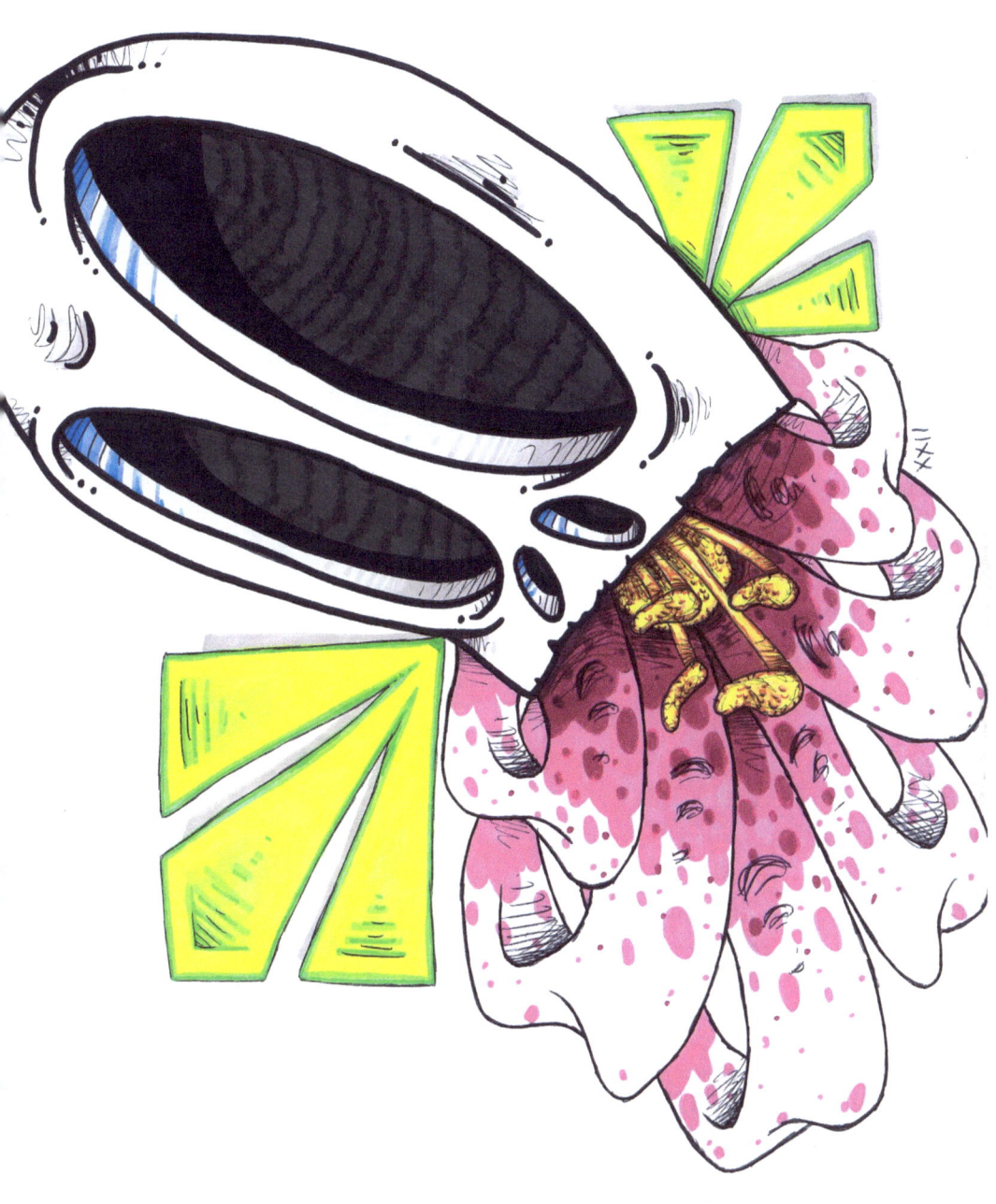

McGee

Thinking of Barry McGee's bottles and B/W screw.

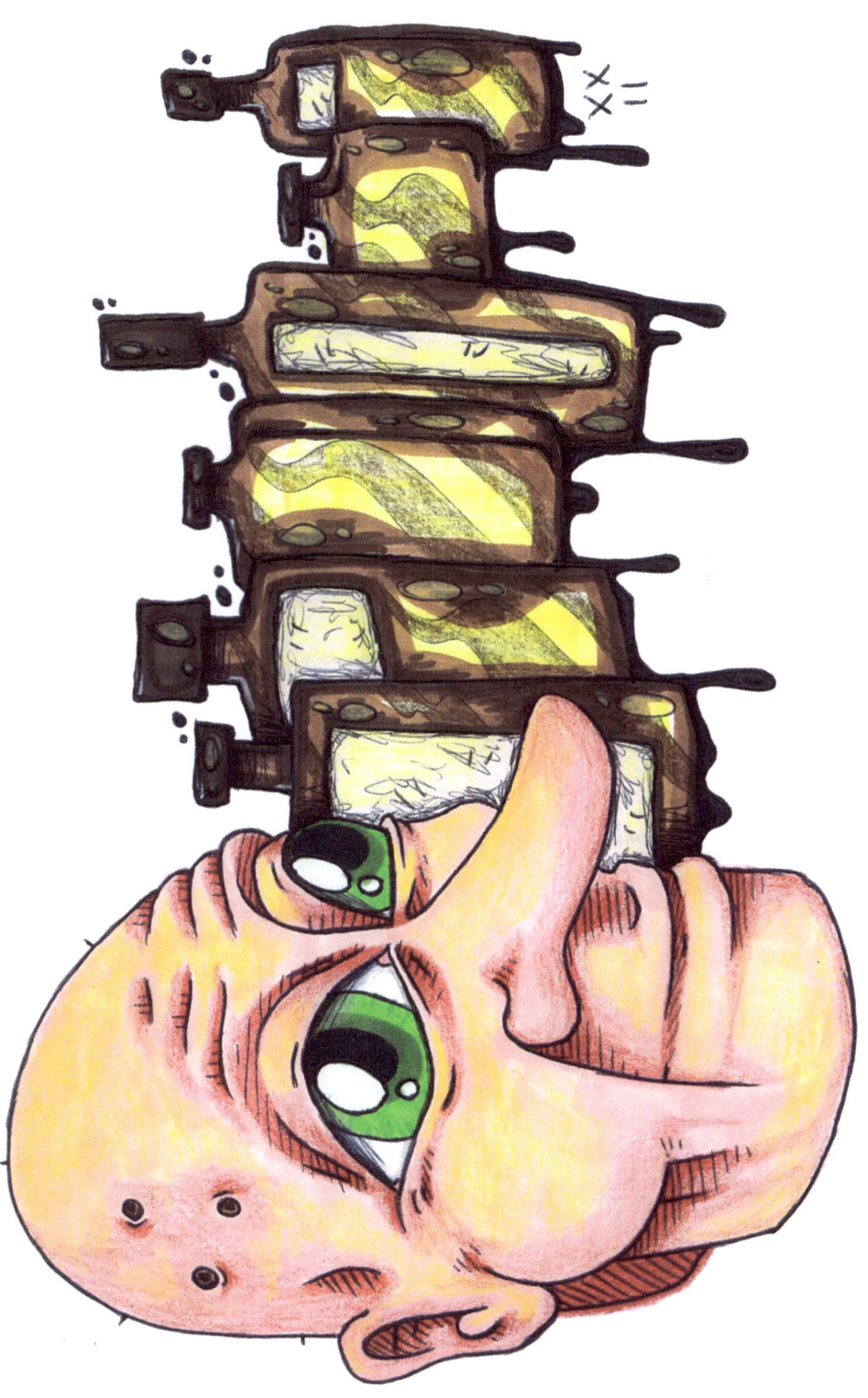

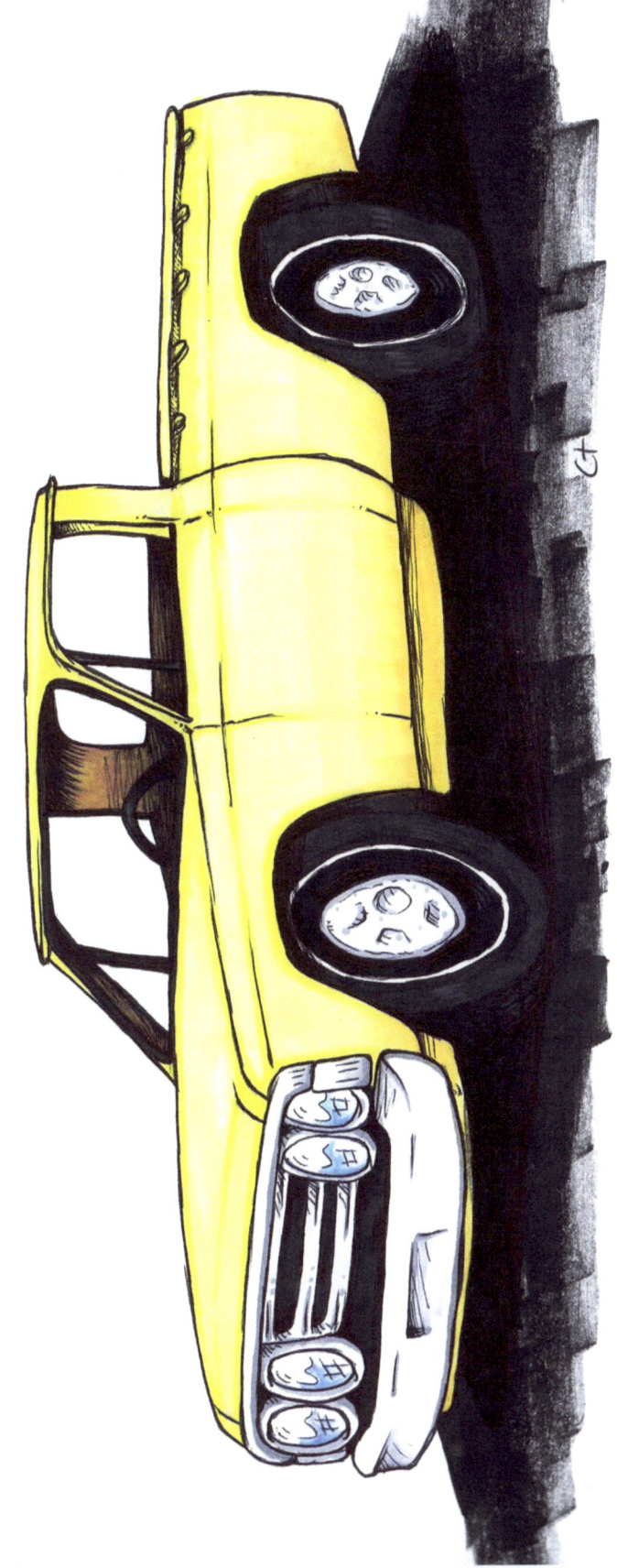

C+ Bike

Cartoon of my bike and some C+ action.

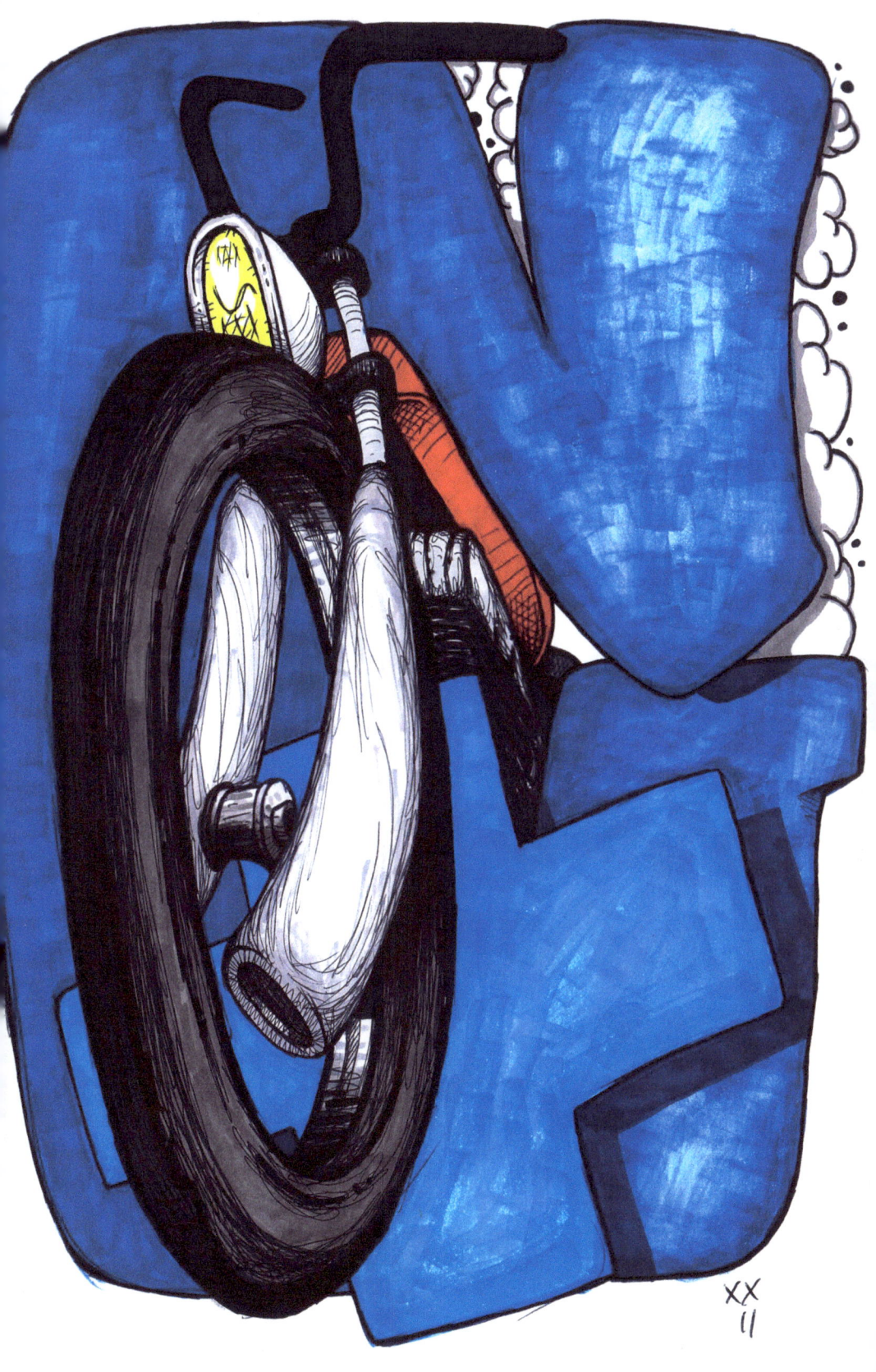

Babel

Basquiat's tires with white paint.

Milton

Robert Rauchenberg changed his name in 1947.

Loveless

Family badge

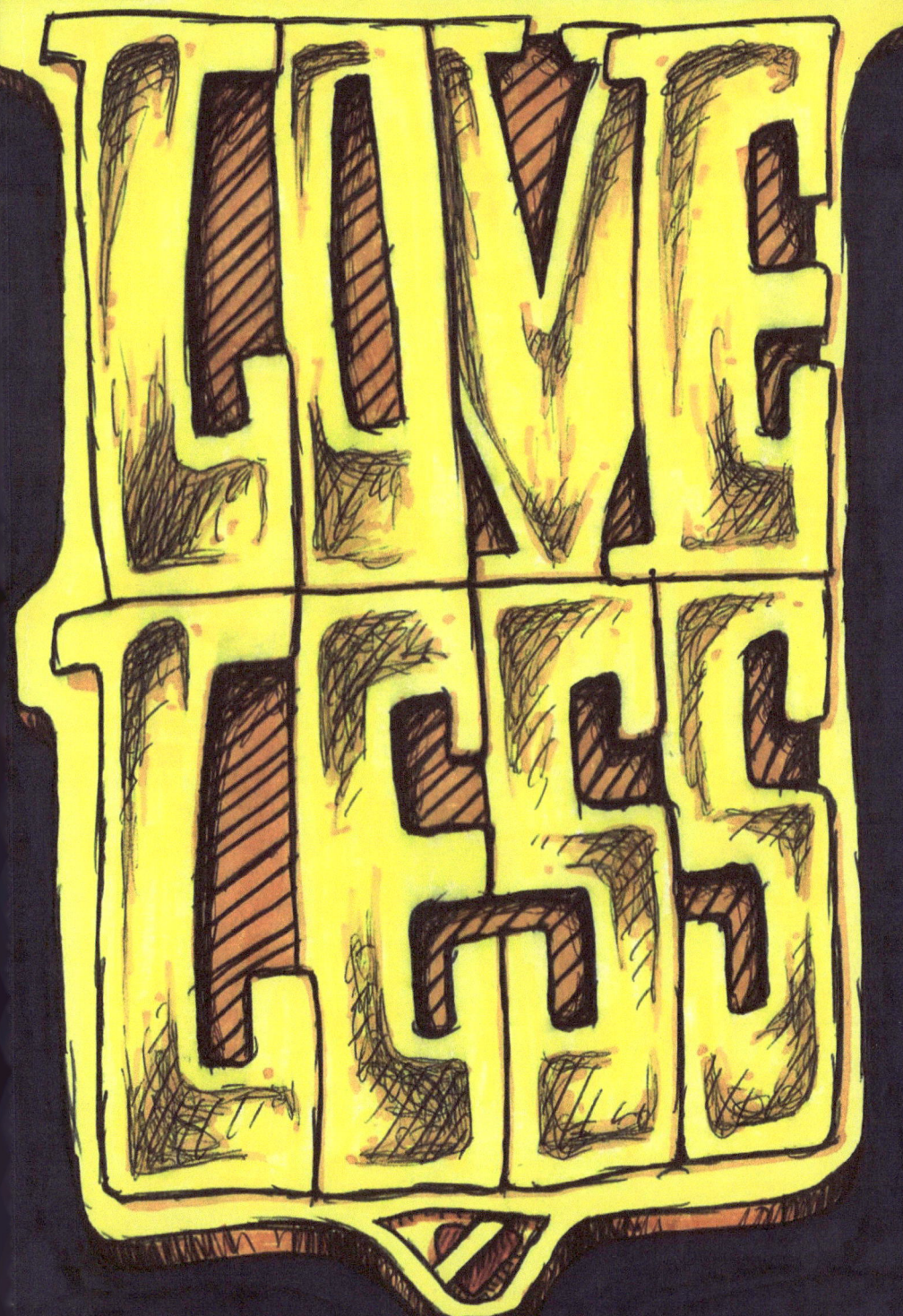

Barfly

Reading alot of Bukowski.

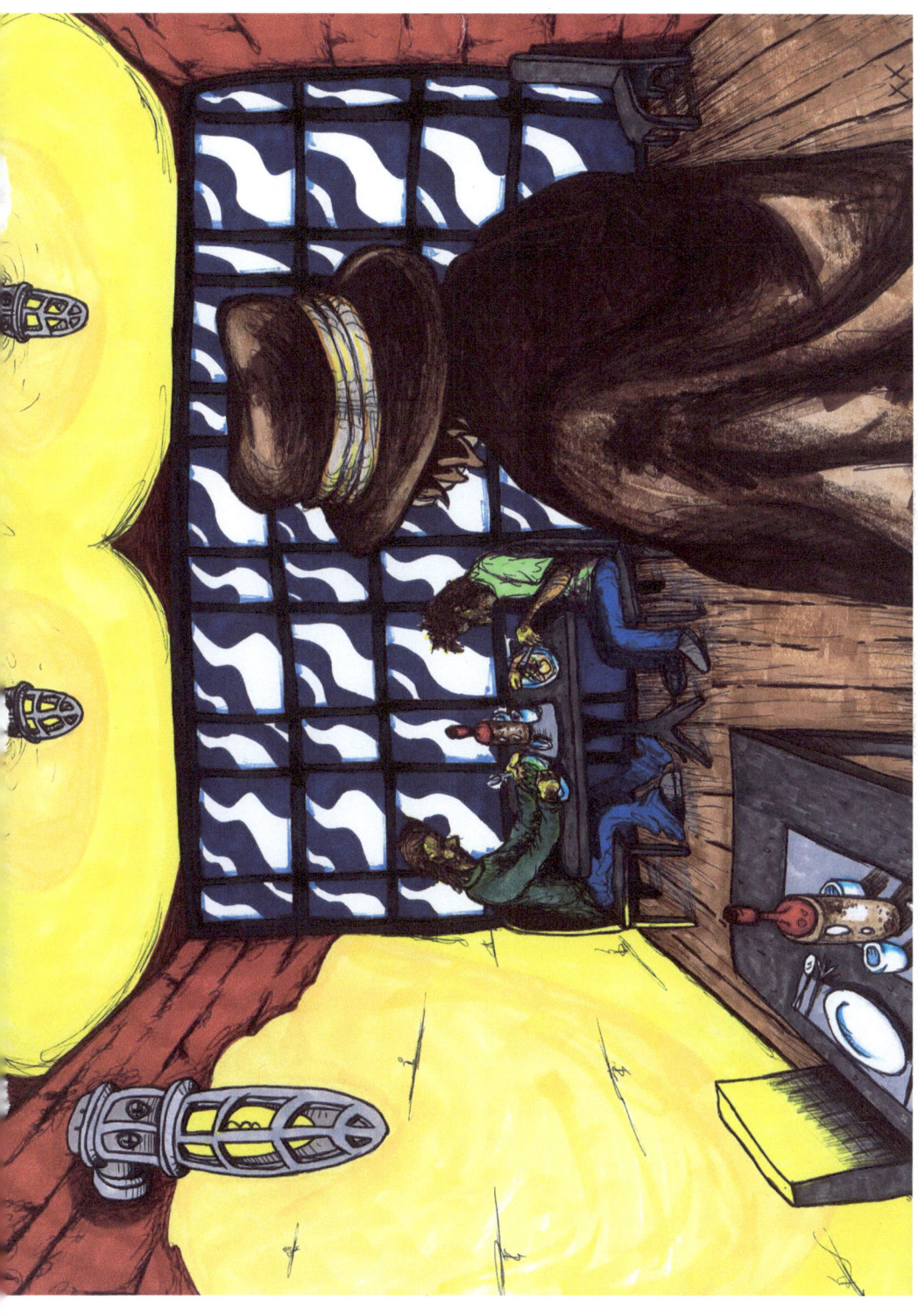

Blood Bullet

CK is Dead, so his art must be worth a bunch now.

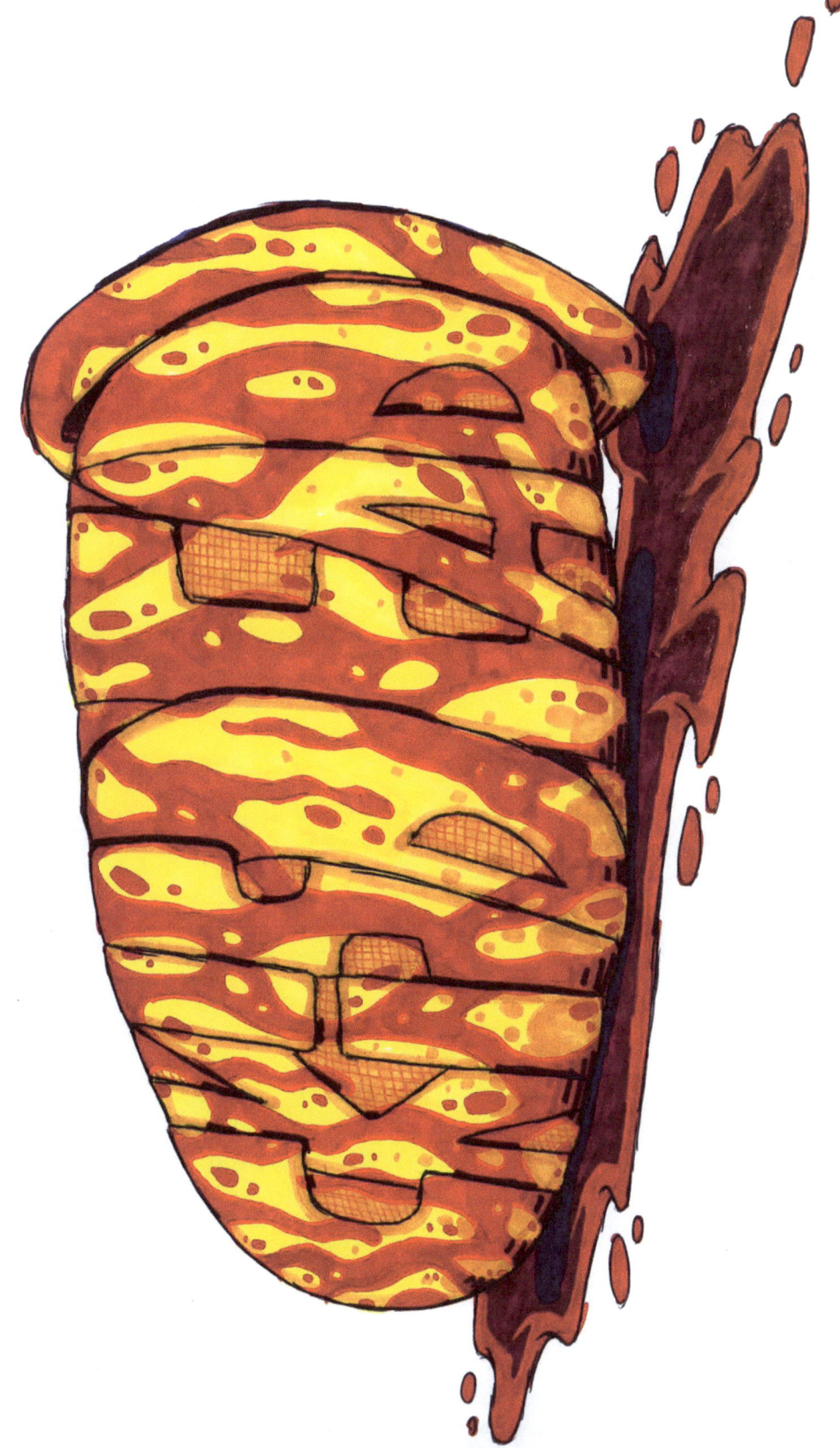

Go to... ChrisKentArt.com